CW01239714

Bat Girls & Acid Boys: The Spontaneous Drawings of Leigh Bowery & Friends
Edited by Richard Torry & Jonny Trunk

First published by Strange Attractor Press in 2025
© 2025 Strange Attractor Press
All images licensed by Trunk Records

Design and layout Louise Mason
ISBN: 9781917319003

Richard Torry and Jonny Trunk have asserted their moral right to be identified as the editors of this work in accordance with the Copyright, Designs and Patents Act, 1988. All rights reserved. No part of this publication may be reproduced in any form or by any means without the written permission of the publishers.

Distributed by The MIT Press, Cambridge, Massachusetts. And London, England.
Printed and bound in Estonia by Tallinna Raamatutrükikoda.

STRANGE ATTRACTOR PRESS
BM SAP, London, WC1N 3XX UK
strangeattractor.co.uk

BAT GIRLS + ACID BOYS

**SELECTED BY
RICHARD TORRY**

FOREWORD

Soho. For centuries it has been the beating heart of creative London; the haunt of artists, literary figures and fabulous historic deviants. And running right through the middle of it is Old Compton Street.

Historically, and literally, this thoroughfare has been at the centre of Soho history: in the early 19th century the dwarven cobbler George Wombwell began his crazy travelling menagerie here, with two lively snakes bought on the London docks. Fleeing debt in his native Germany, Richard Wagner lived at The Kings Arms (probably at number 5-7 Old Compton St) in 1839 and began what was to become his opera *The Flying Dutchman*. In the late 1920s The Chat Noir (at number 72) was the late-night café hang out for Quentin Crisp and his fellow catamites, while by the late 1950s modern British pop emerged from the tiny basement at the 2i's Coffee Bar (at 59) with acts like The Vipers and Tommy Steele getting their start there.

But for the purposes of this book we need to visit Old Compton Street in the early 1980s, when Soho was about to explode with creativity once more, becoming the epicentre of joy, madness and a new, progressive club culture.

A third of the way along the road, nearly opposite the Algerian Coffee Stores (number 52, established 1887) is a little grey door with a buzzer. This was, and still is, the entrance to Richard Torry's small second-floor flat, his home since March 1981.

It was here that Richard created a dramatic, friendly space – a small, one bedroomed improvised playground / salon / bar / art space / studio with floors covered in cut-out pictures from scrap books, periodicals and porn mags.

At the time, Richard was a successful designer. He'd studied fashion at Middlesex Poly, worked for Vivienne Westwood, and had just started his own clothing label. His knitwear had become the stuff of international catwalk dreams, and through his various fashion and street connections he'd met an expanding group of like-minded creatives from all across London, including the soon-to-be-legendary Leigh Bowery.

For many of these creatures of London's burgeoning art, fashion and club scenes, Richard's flat was perfectly-placed for congregating in the daytime or before / after nights out – a space to laugh, cry, drink, eat, smoke, work, bond and create. Into this tiny flat would pour 10-20 people, regularly enough to make the neighbours complain. Judy Blame and John Moore (founders of the legendary House Of Beauty And Culture in Dalston) would come in the evenings as, at the time, Dalston was dead at night, unless you were "on the game". Often in the daytime, people would just come in to work: in the pre-digital age photographers, designers and stylists would get their photos developed at Joe's Basement, 100 yards away, and drop in to the flat to look through them.

It was here, on the many, many occasions throughout the decade that followed (1983-1993) that the set of drawings we present here were created.

Richard would encourage his guests to play Exquisite Corpse / Consequences. Using piles of old scrap paper (including a fashion contract he'd used, as you'll see), the games would begin.

I'm sure you know how the game flows, but just in case, this is how Richard and his friends would play: they'd start with an improvised name, or idea, as a catalyst – say "Acid Boy" or "Bat Girl". This was written at the bottom of the paper, which was then passed to the next person who would start drawing the head. Once this was done, the top of the paper was folded to hide it, still showing the name / theme at the bottom. This was then passed on, the next person drew the body, and so it went. Eventually the complete figures would be unfolded and revealed, often with everyone falling about laughing.

Richard used the games as a catalyst for creativity, for loosening up, as a great prelude to band practice or lyric writing. Or just for a right laugh.

It's worth noting that many of the games were played during the classic Taboo / Kinky Gerlinky period as, once Acid House came along in 1988/89, people were far too smashed to play anything at all. But the games continued once acid had passed, right up until Leigh died in 1994.

The resulting drawings are quite astonishing in many ways. My first impression when I saw them was that they perfectly captured the essence of the edgy club and fashion scenes of the time. They also hint at the artists themselves: there is more than a whiff of Leigh Bowery across many of the outfits, hats, shoes and inky stylings that you will see over the following pages. That each drawing was spontaneous, while also the work of many hands (a list of the players over the years can be found on the cover flaps) leaves them open to some fascinating interpretations.

What you will see is an explosion of silliness and daftness, all explored in a brilliantly avant-garde and inspiring fashion – as was the way of the Torry / Bowery scene. You can also hear laughter and joy emanating through the drawings, and we all need more of that – all the time.

So here they all are. The more you look at them the more you see. Sorry about all the cocks. And, once you've enjoyed the book, I suggest you go and start your own game…

Jonny Trunk

I'd like to thank Richard Torry twice – for having the foresight to keep the drawings safe for all this time, and then for entrusting me with them for this publication.

THE DRAWINGS

COWBOY

COWBOY

WET DIANA ON BRIGHTON BEACH

Wet D... Brighton Beach

SNAKEFOOT

DISCO DISCO DISCO

"disco.disco.disco.disco.disco"

DESPERATE LIVING

DESPERATE LIVING

AN ACNE COVERED ADOLESCENT

An Acne covered Adolescent

ANDY WARHOL

ANDY WARHOL

PAM HOG

PAM HOG

BIG LEGGY

FLOWER POWER

THE ULTIMATE MISS UNIVERSE

The ultimate miss Universe

BOY GEORGE

Boy George

SUSANNE BARTSCH REALNESS

POPATA

CAMERA GEAR
c/o MEDIA DEVELOPMENTS
Contact: David Cooper
Tel: 01 573 2255

1 x Arri 3 Steadicam kit
1 x set of primes (16mm - 85mm)
10-100mm Zoom
Tall and short legs
Unit Box

Transmitter c/o: Simon Bray
Television c/o: Fiona

LIGHTS
c/o FILM LIGHTING SERVICES
Contact: Ashley Palin
Tel: 01 858 9511

12 x space lights
10 x 5K cyc lights
10 x 5K sky pans
4 x 2K Fresnels
4 x 2k fresnels
2 x 2K silhouettes
4 x parcans
2 x red heads
2 x mizars
2 x 5K dimmers
1 x 2.5K 6 way

DRAPES
c/o ALREGENE
Contact: Wayne Thompson
Tel: 01 733 1047

2 x 20' x 60' white drapes
1 x 38' x 22' drapes
1 x 29' x 20' drapes

FILM STOCK
c/o POPATA
Contact: Fiona

5 x 400' rolls Kodak 5296 - 500 asa
8 x 400' rolls Kodak 5247 - 320 asa

POPATA LTD. (UNIT 213/5/9) CANALOT PRODUCTION STUDIOS, 222 KENSAL RD, LONDON W10 5BN. TEL 968 9939 FAX 968 6944
REGISTERED ADDRESS: 'THE COLONADES' 82 BISHOPS BRIDGE RD, LONDON W2 6BB REGISTRATION NO. 2248 568 VAT NO. 512641674

SUSANNE BARTSCH REALNESS

SPACE SLUT

EARTH BASE CALLING SPACE SLUT. COME IN SPACE SLUT

SPACE SLUT..

BEAUTY FULL LOVELY

"HELLO!!!"

Beauty full.
Lovely.

TECHNOLOGICAL PERSON

VESSEL

WHY ACCESSORIES ?

Because clothing has become simpler, accessories have an increasing importance in fashion. Buyers have traditionally looked to Britain for accessories and knitwear, buying designer clothing from Paris or Milan.

In accessory design, there are a wide variety of products available, but until **"VESSEL"** there were no contemporary fashion-related bag designs on the market.

"VESSEL" with a design awareness of the weighted posture and the silhouette of carrying has a contemporary relevance, unlike other bag labels which are either traditional and hand held, styled for a 70's sensibility.

Vuitton	Gucci
Lancel	Lowe

or directly derivative of sportswear, styled for an 80's sensibility

Hi-Tech	Pink Soda	Body Glove

Sportswear has brought pouch bags, rucksacks, bum bags, bright holdalls, into everyday wear. The fashion of sportswear will change, but the practicality of body worn bags will stay. "Vessel" takes this practicality, to sophisticated forms.

In its maturity the **"VESSEL"** label will encompass a number of mutually compatible ranges from leading fashion items (for Press and Hi-Fashion stockists), a range of **"VESSEL"** classics which will establish a loyal clientele and a softer\fabric diffusion range for the luxury end of the high street.

TECHNOLOGICAL PERSON

LADY BOY

SPORTSMAN

SPORTSMAN
TENNI-

ACID JAZZ MAN

"Acid Jazz man".

BUSINESS MAN

BUSINESS MAN

THIERRY MUGLER

COWGIRLS IN SPACE

COWGIRLS IN SPACE

MORE CHAMPAGNE

ORIENTAL TART

ORIENTAL TART.

RICHARD IV

SEX

DICK MAN

A FAIRY

A FAIRY

DAME FIONA

WHEN WE MET FIRST TIME

When we met first time

AD EXEC

POLICEMAN

AUGUST NEWSLETTER Page 2

Also if you want to take part in the new experiment of having a central
showroom for American visitors for one week only - this will be at Stuart
Hudsons Showroom (address as previous page) from August 20-24. Please make
sure you leave garments/ranges there by 17th August.

This will be done by appointment only so anytime we know that customers are
going there we will phone you. It is up to you to have someone there if you're
interested in meeting the customer, we will not do this for you.

- It is an experiment, it may or may not work, but as its not costing members
anything we believe its worth a try.

-Also during these days Jane will be holding a Press Preview Day to invite spec-
ific journalists in to look through ranges so this is another reason why its in
your interests to have some merchandise there.

POLICE NOTICE.

Scotland Yard have informed us they are investigating an incident at Stephen
Kings prestigious shop in Kings Road when windows were plastered with "Closing
down sale", "Everything must go" and "Under new management" stickers. The vice
squad who are handling these are looking into all Stephens enemies who are obviously
suspects. These include:-
women in general
Kings Road shopkeepers
talented menswear designers
Mary Reed, John Sarsfield, Su Nicholson and ex-staff...............

A reward is offered for further information leading to an arrest, of Stephen
Kings own book "How I became as big as I am today".

..

Paris : Sehm - Dave Dugdale on 625-5085 is organising the van to take the
blinds, posters, P.R. brochures etc and merchandise and carnets of exhibitors
who are interested in sending their collections over to Paris this way, Every
exhibitor will be expected to pay towards sending the general equipment over,
and the main balance split between the exhibitors whose merchandise goes in the
van.

- Merchandise and properly completed carnets must be at BMDC office by Wednesday
August 29th without fail so we can check all the carnets - n.b. if the carnet is
incorrect we will not take the merchandise as this will jeopardise everyone else's!

Incidently Dave is also the Committee Member responsible for organising our new
Seminar - How to get your act together. This is basically to help all of us,
experienced and new designers - refine and improve our business acumen. We
propose having experts talk on Finance, Accounts, Sales and Presentation and
possibly Production.

This is an idea that the Design Network in San Francisco gave R.D. on his recent
visit, and they have found this to be enormously beneficial for all the members,
and they now hold them on a regular basis.

Watch this space for the announcement of the date and final details - if you
want to help phone Dave direct (but don't mention under any circumstances
Australian poufs - its a sore point with him !)

SPLIFF SMOKER

SPLIFF SMOKER

FRUSTRATION

FRUSTRATION

AN AMERICAN IN PARIS

an American man in Paris

BAT GIRL

BAT GIRL.

FLOWER POWER CROTCH

PHANTOM

E·M·D·C

·ENGLISH·MENSWEAR·DESIGNER·COLLECTIONS·

99, Kenyon Street, London, SW6 6LA TEL. 01-381-0951/6783

IMPORTANT LETTER TO ALL MEMBERS

This is just to inform you that the vote we took on the Constitutional issue of showing in London resulted in an overwhelming majority to leave us a status quo. This has given us a very clear mandate now to negotiate with Imbex, which we've now started to do.

I'm delighted that this very healthy exercise was carried out with a great deal of thought by all members, and once again has demonstrated that we can conduct our affairs so amicably and democratically.

It does of course also mean that this issue can be raised again in the future if the body of the membership so require. In the meantime I would urge the few members who voted for change to respect the wishes of the majority and enthusiastically participate at Imbex with everyone else.

THIS IS THE FINAL REMINDER TO KEEP SELLING EXTRAVAGANZA TICKETS. IT IS ALSO A REMINDER THAT YOU ARE ALL EXPECTED TO SELL AT LEAST 10 TICKETS, PREFERABLY MANY, MORE BUT AS AGREED YOU'LL BE EXPECTED TO PAY FOR 10 REGARDLESS OF YOUR EFFORTS.

WE NEED THIS OFFICE/SHOWROOM, WE NEED A GENERAL SECRETARY, DESPERATELY TO GO FORWARD IN THE NEW YEAR, AND ALSO CLIVE AND ANNE AND THEIR TEAM HAVE PUT TOGETHER AN AMAZING AND EXCITING EVENING.

ALL MEMBERS ARE EXPECTED TO TURN UP AT 8.00 PM ON THE NIGHT TO HELP WITH THE ARRANGEMENTS.

Chairman: ROGER DACK
Press Enquiries: 01-381-6783

BODYMAP

FUSTRATION!

FUSTRATION !

UNNAMED FROG WOMAN

DREAM FOR EVERYONE

Dream for Every One

Y.S.L. TOP MODEL IN SHOW

Y.S.L TOP MODEL IN SHOW—

CAPTAIN HOOK

NEW AGE

WHEN THE ITALIAN HUSBAND EATS PASTA

When the Italian husband eats Pasta.

FAG ASH LIL

FAG ASH LIL

FAG HAG

FAG
HAG

TIM WHEELER

TIM WHEELER WITH A COCK IN HIS ARSE

FASHION EXHIBITOR

FASHION
EXHIBITOR

ECOLOGIST

FUSION

FASHION SHOW

M.C. CARYN FRANKLIN

26th APRIL 1990

ALL DONATIONS TO THE TERRENCE HIGGINS TRUST

DRINKS....19:30....;
FASHION SHOW....20:00

ADMIT TWO

13, COVENTRY STREET...LONDON....W1...TEL:...287-8828....

FRUIT MAN

Fruit Man.

SEVENTIES MAN

AMBIENT NINNY

"AMBIENT NINNY"

GAY CATHOLIC PRIEST

Gay Catholic Priest.

P TO DO LIST

1. Buy linning for Simon Baker. Later Today.

2. At HOBAC
 Buy Vessel stamp at Batchelors $25 ?
 Take Ian 1 skin of leather
 Get a good Thrust bag for Guy
 Pick up star sholder bags.

3. Chris type in Business plan

4. Cash Flow

5. Sew up lining of Body Wrap Bag Teach Chris how to

6. sew in lining's

7. LOOT Keep puting adverts for Knitters in loot. Phon

8. e

9. Concept for I.D editorial, write any ideas.
 Consider the way the tramps of Soho dress

10. Appointments with
 Liberty
 Janet Fitch
 Harvey Nichols
 Browns

11. Get proof of shipping from Robot [Tokyo Boogie Bea

12. t]

13. Buy
 plastic sheets Rhymans

14. Andy Greaves
 Phone 0484 682 788
 and write to him.

15. Answerphone mended at John Lewis

16. Change Estate Agents to Ricketts Boreham or other

17. Write alterations of
 snakes in squares inc moss stich
 twisted sleeve
 write down double moss stiches stich

18. Launa

GOGO ON TV

But... I'm so Horny!!

GoGo on TV

GOSPORT

COVER GIRL OF THE 90S

cover girl of the 90's

HAIRY PERSON

HAIRY PERSON.

SPACE TRAVELLER CREATURE

SPACE
TRAVELER
CREATURE

A JAPANESE TOURIST IN LONDON

A JAPANESE TOURIST IN LONDON

JOHN LENNON

John Lennon

KINKY BOY LINKY

KINGKY BOY 'LINKY

Vessel I *Draft only*

RICHARD TORRY "VESSEL"

April 1990

WHY ACCESSORIES → subtitle

← OBJECTIVES/AIMS subtitle

← MANUFACTURING

← MARKETING

PRESENTATION subtitle of Marketing

SELLING POINTS

← FUTURE DEVELOPMENTS

SELLING/MARKETING?

PROMOTION /AND P R

STUDIO

EMPLOYEES

CAPITAL ITEMS

DEVELOPMENT

" " STOCKISTS OF "VESSEL"

ACID BOY

ACID BOY

MARGARET THATCHER

Margaret Thatcher.

2001 YEAR MALE FASHION MODEL

2001 Year Male fashion Model

MARTIN DIMENT

Martin Dumont

MIKAËL JACKZON

Mikaël Jackzon !!

YSM (YVES SAINT MASO)

YSM
(yves saint maso)

MONTAGE

MOSCHINO

MR & MRS WEEEKS

Mr & Mrs WEEEUS

NO NAME

DRUGS

DRUGS

DERANGED PERVERT

nails → ← straps → sandles

DERANGED PERVERT

FRUITS

FRUITS

OPEN FOR YOU

OPEN FOR YOU

PANSY

PANSY

JAPANESE GIRL FASHION DISASTER

JAPANESE GIRL FASHION DISASTER

A NEW ROMANTIC

A NEW ROMANTIC

PEKINESE

Pekinese

YOUNG PARISIANS

young parisians

BABY ONE!!

BABY ONE !!

TRENDY POLITICS

"TRENDY POLITICS"

WOODSTOCK '90

WOODSTOCK '90 - 20 YEARS ON

PICASSO'S MUM

PICASSO'S
MUM

RICH OLD WOMAN IN COUTURE OUTFIT

RICH OLD WOMAN IN COUTURE OUTFIT

MUSCLE MARY

NEW PERM

AUGUST NEWSLETTER Page 5

<u>Do you want to eat in Paris?</u> To ensure you get the right meals this time phone
Julian at BMDC office now so that he can erm um erm um practice in advance !

Roger reports that his visit to the <u>San Francisco Design Network</u> was very
interesting and useful especially comparing notes on how our individual organis-
ations are run – we pinched the ideas of Seminars and the Extravaganza from them –.
One of their committee members, Babette (yes, really, Babette) is in London in
September so we have invited her to return the compliment of talking to us after
our Meeting on Tuesday 20th September. It would be nice to make this into an
unofficial social gathering after we have cleared up our business – please make
a note of this date in your diaries.

Lets now have your comments and/or contributions for the Newsletter – especially
the gossip............ Also do you like the way BMDC is run, would you like to get
more involved? The A.G.M. will be here in October when it will be the time for all
of us to elect a Chairman and Committee – so if you feel you can offer the group
something, and are prepared to put in the necessary effort and work. We'll be
looking for nominations at the September meeting.

............................

CLASSIFIED ADVERTISEMENTS

<u>School Leaver wanted</u> – to fill position of Personal Assistant of large designer –
apply Stephen King.

<u>Lost</u> one pair shades in the back of a really great club that gives free drinks in
Tokyo. No reward.

<u>Designer Family Planning Classes</u> meeting regularly – phone Charlie Allen for
details.

<u>Wanted</u> – the recipe for the blue/greendrink served at BMDC Paris party that makes
me randy and sick – apply Su Nicholson.

SQUATTER

SQUATTER

MALIBU

TARA IN Y FRONTS

THE/A QUEEN

THE/A QUEEN

BANG BOY

DISCO BOY DISCO

BANG BOY

CALL ME BEAUTIE! (INDEED!!)

Call me Beautie..! (indeed!!)

UNGARO

UNGARO

BIG LIPS

CHRIS SKATEBOARDING

CHRIS SKATEBOARD

WORLD TRAVELER

WORLD
TRAVELER

70S GLAM POP STAR

THE SWAMP THING

THE SWAMP THING WAS LAST SEEN IN A FRENCH RESTAURANT!!!

HAT PERSON

FAG ASH 'LIL'

FAG ASH 'LIL'

STRIPPER

STRIPPER

PLATFORM 2

SCHOOLBOY

SPACE PERSON

TRIPLE TITS

STRANGE ATTRACTOR PRESS
2025